Life is a canvas, and we are it is up to us to paint a beautiful picture.

I hope from my heart that you'll enjoy this book and find that it's a place where you can relax, recharge, and renew, as you let go and let your creativity flow.

As kids, many of us enjoyed coloring. Remember how that big, yellow box of crayons could captivate our imaginations for hours? When we entered the adult world, we most likely traded our carefree doodling for crossing items off our long to-do lists. But as adults, we need time to play, too—to nourish our hearts and renew our spirits, and that's what this book is intended to do. Do you sometimes feel like your whole day is devoted to taking care of the needs of others? You're not alone. When you feel this way, it's time to give yourself a break, nurture yourself, and let your mind relax in an expanding swirl of colorful patterns and designs.

True happiness comes from the inside, and we can miss it if we're constantly focusing our attention outwardly. For all the giving and guiding women do, we sometimes need a quiet, simple activity like coloring to let us rest in a place of ease and creativity. Some people call it a state of "simple awareness," a state that's nourishing to the mind and heart.

While researching my book *Happy for No Reason,* I interviewed some of the happiest people in the world, and discovered one thing they have in common is that they all take time for themselves on a regular basis. Many of them practice some type of relaxation or meditation daily. I was excited to learn that, according to recent research, coloring can wonderfully accomplish both of these.

The Benefits of Coloring

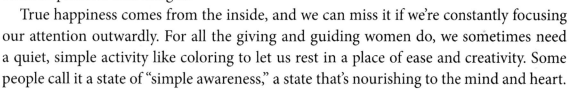

Yes, believe it or not, scientists have studied coloring, and they've found that it quiets your mind, calms your thoughts, reduces stress, and allows you to simply be. Research shows that coloring can induce a kind of "flow," or active meditation, during which you lose your sense of time and your brain waves fall into a calming rhythm. As a result, worries fade away and creative blocks can become wellsprings of ideas.

What You Think About Comes About

I am a true believer that what you think about comes about and what you focus on in your life expands. So, as you read these quotes by and about some amazing people, let them remind you of how amazing you are, and how you can use your unique gifts to make each day the best it can be. You'll also find ideas below about how to customize the mandalas by embellishing them with your favorite quotes or phrases—in this way, each mandala can become a visual representation of something meaningful to you.

Whether you want to go elaborate or stay simple, by getting into the habit of coloring, you carve out time for yourself, tap into your creative energy, and remind yourself that you are important. Taking time to honor your creative side is not selfish or silly—it's essential. Think of any time you could reclaim during your day by doing something nourishing for your heart—perhaps you could try it the next time you're sitting at the coffee shop waiting for your latte or while sitting on the couch in the evening instead of channel-surfing. Many people like to color at the end of the day as a way to unwind and set an intention for the day to come.

Just like the spaces in this book waiting to be filled with colors, every day is a blank canvas waiting to be filled with life. We hope you enjoy this book and find that it helps you to color your world a brighter and happier place.

—To your happiness, Marci Shimoff

Do-It-Yourself Mandalas

There are countless ways to make each piece of art your own, including the mandalas. You can add decorative backgrounds or write in a quote. Use the examples shown here as a launching pad for your own creativity.

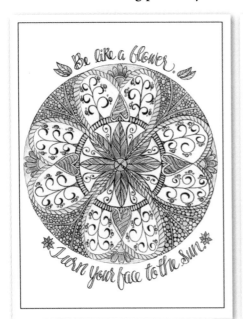
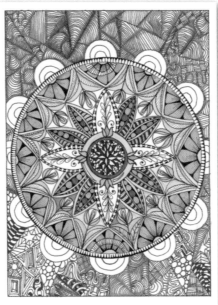
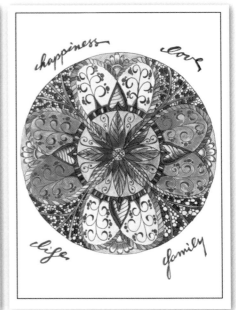

The Meaning of Mandalas

The word *mandala* means "sacred circle" in Sanskrit. Since ancient times, holy people from many traditions around the world have used mandalas as a way of evoking spiritual energy and healing. Mandalas symbolize wholeness, unity, and the cycle of life, and they appear in nature in many forms, such as flowers, snowflakes, and the sun and moon.

The psychologist Carl Jung used mandalas as a healing tool, and research has shown that creating and coloring mandalas can relieve stress, reduce anxiety, and calm the mind.

Each mandala in this book was specifically designed to help you turn your energy inward and instill a sense of peace and tranquility. At the end of the book, we invite you to create your own mandala, using the instructions as your guide.

A Note from the Illustrator

THANK YOU FOR ALLOWING my artwork to be the canvas for your coloring adventures. Most adventures need some directions, so here are mine:

1. Pick a page.
2. Pick a medium.
3. Play.

I created every illustration with that third instruction in mind because what's the point of a coloring book if you can't have fun with it?

Each page is filled with details, which you can approach in many different ways. You can individually color each tiny shape, or you can group them together into bigger sections, which all come together to form a whole. You can leave parts blank for little pops of white space, experiment with color combinations, and play with different palettes, tones, and hues.

Try doodling sections instead of coloring them—you can copy my patterns or make up some of your own. You'll notice that some of the pieces include inspirational words or quotes within the artwork. Feel free to write your own words into the spaces or freehand your favorite inspiring quote around the outside of the mandalas. Choose words that are personally meaningful and powerful, and think about them as you explore your own creativity. (I often do that when I draw, making art a form of meditation for me.)

Each page is designed to stir your imagination, and really, the possibilities are endless. The right way to use this coloring book is YOUR way, and I encourage you to relax, have fun, and enjoy the creative process!

Coloring Tips & Tools

TIP: Experienced colorists often add a piece of scrap paper under each page they are working on to make sure that the ink doesn't bleed through the page and so that they don't make indentations on the next page if they press hard or use very sharp pencils. It's a good trick to try!

COLORED PENCILS: great for shading or blending colors together, both of which add interest and depth to any design.

GEL PENS AND MARKERS: good for adding bold, defined bursts of color.

CRAYONS: surprisingly versatile when filling in large spaces.

Choose Your Colors

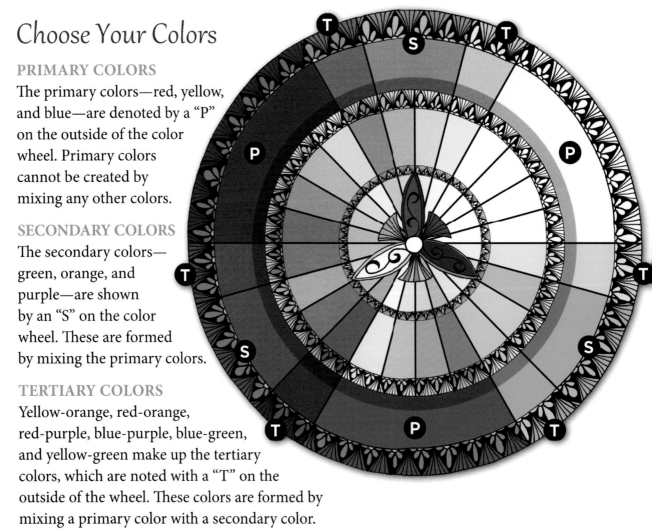

PRIMARY COLORS

The primary colors—red, yellow, and blue—are denoted by a "P" on the outside of the color wheel. Primary colors cannot be created by mixing any other colors.

SECONDARY COLORS

The secondary colors—green, orange, and purple—are shown by an "S" on the color wheel. These are formed by mixing the primary colors.

TERTIARY COLORS

Yellow-orange, red-orange, red-purple, blue-purple, blue-green, and yellow-green make up the tertiary colors, which are noted with a "T" on the outside of the wheel. These colors are formed by mixing a primary color with a secondary color.

The colors on the top half of the wheel are considered the warmer colors whereas the bottom hues are the cooler ones. Colors that fall opposite of one another on the wheel are complementary, and the ones that fall next to each other are analogous. You can use both complementary and analogous colors to make a gorgeous piece of art—the possibilities are as endless as your imagination.

Harmony How-Tos

JUST AS IN LIFE, BALANCE IS THE KEY to creating harmony in any relationship—even when coloring. You can find a rainbow of inspiration all around you—in the patterns of plants, animals, flowers, sunsets, and even the morning sky.

A nature-inspired color scheme with analogous colors

ANALOGOUS COLORS are any three colors which are side by side on a 12-part color wheel, such as yellow-green, yellow, and yellow-orange or teal blue, blue, and indigo.

A nature-inspired color scheme with complementary colors

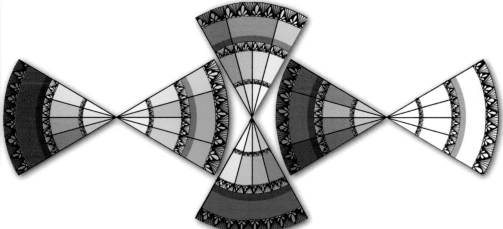

COMPLEMENTARY COLORS are any two colors which are directly opposite each other, such as yellow and purple or orange and blue.

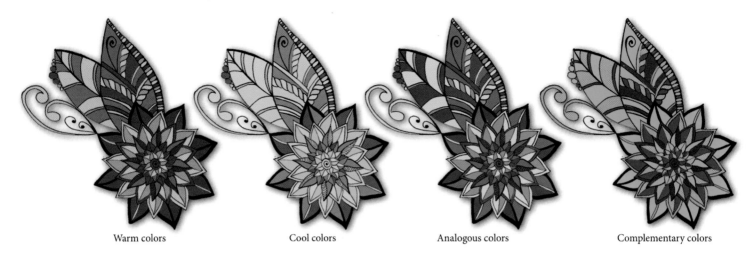

Warm colors Cool colors Analogous colors Complementary colors

The Meaning of Colors and Imagery

According to color psychology, the following colors are associated with certain feelings:

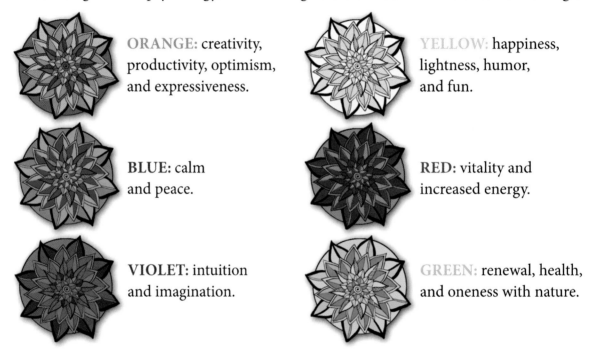

ORANGE: creativity, productivity, optimism, and expressiveness.

YELLOW: happiness, lightness, humor, and fun.

BLUE: calm and peace.

RED: vitality and increased energy.

VIOLET: intuition and imagination.

GREEN: renewal, health, and oneness with nature.

Despite these nuances, there are no wrong colors. It is your book. Color it your way.

ABOUT THE AUTHORS

MARCI SHIMOFF is a #1 *New York Times* bestselling author, a world-renowned transformational teacher, and an expert on happiness, success and unconditional love. She's authored the international bestsellers, *Love for No Reason* and *Happy for No Reason*, co-authored six titles in the *Chicken Soup for the Woman's Soul* series, is a featured teacher in *The Secret*, and is the narrator of the film *Happy*. Visit her website at *www.HappyForNoReason.com*

JUDY CLEMENT WALL is a freelance artist/illustrator, writer, and intrepid doodler. In addition to her commissioned artwork and illustrations, Judy creates unique cards and original artwork that celebrates life and inspires creativity. To see more of her art and read her published work, visit her web site at: *www.judyclementwall.com*

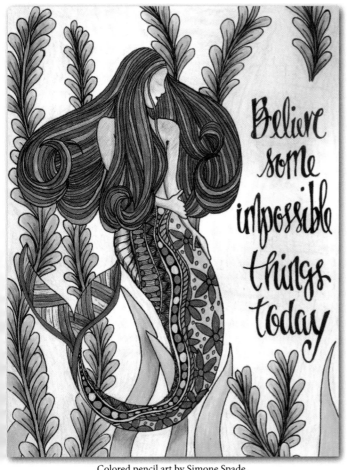

Colored pencil art by Simone Spade.

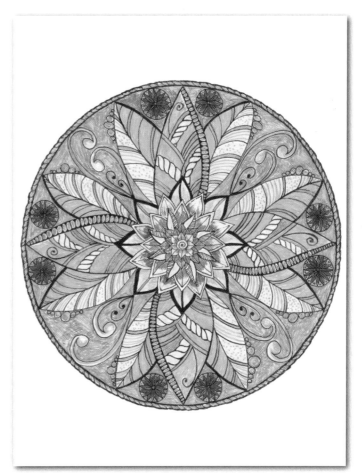

Colored pencil art by Simone Spade.

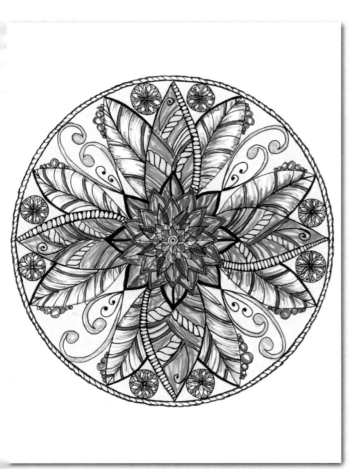

Marker art by Kevin Stawieray.

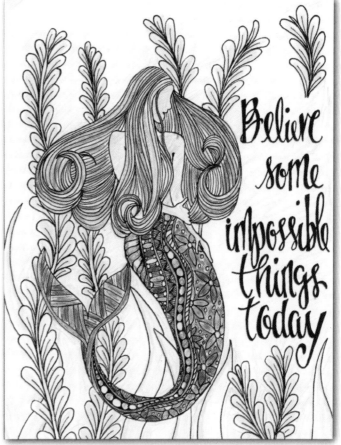

Colored pencil art by Jaime Trillas.

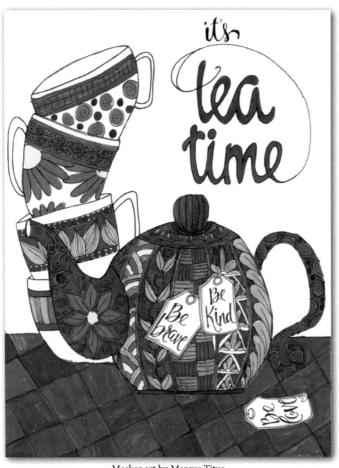

Marker art by Marcus Titus.

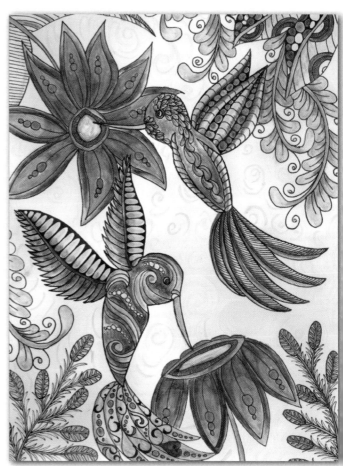

Colored pencil art by Simone Spade.

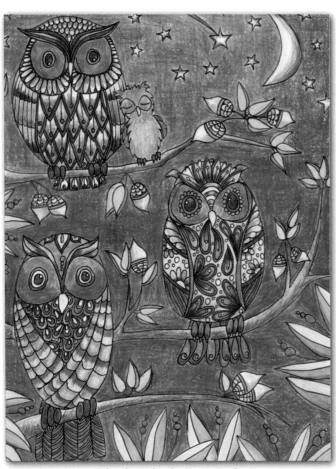

Colored pencil art by Simone Spade.

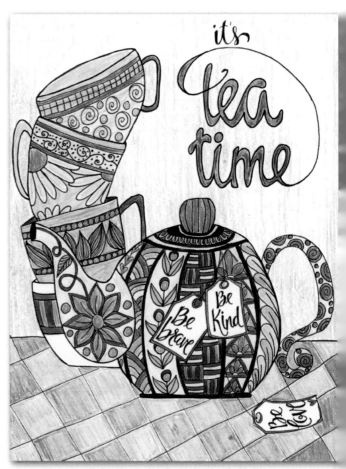

Colored pencil art by Leah Honarbakhsh.

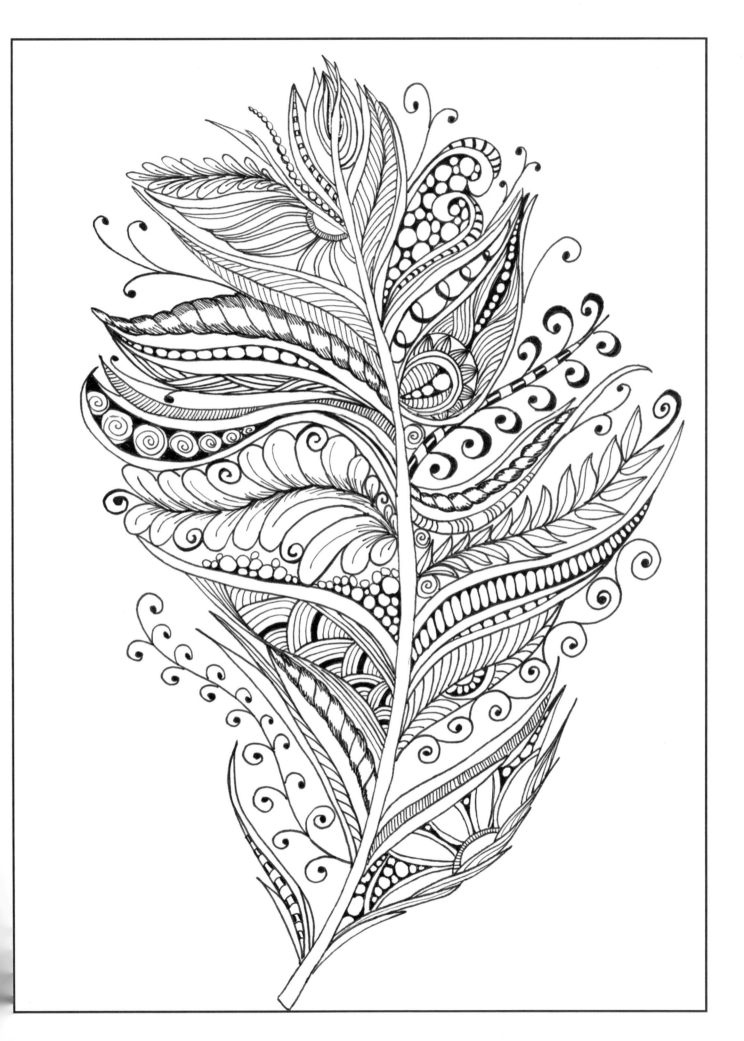

The more you praise and celebrate your life,

the more there is in life to celebrate.

—OPRAH WINFREY

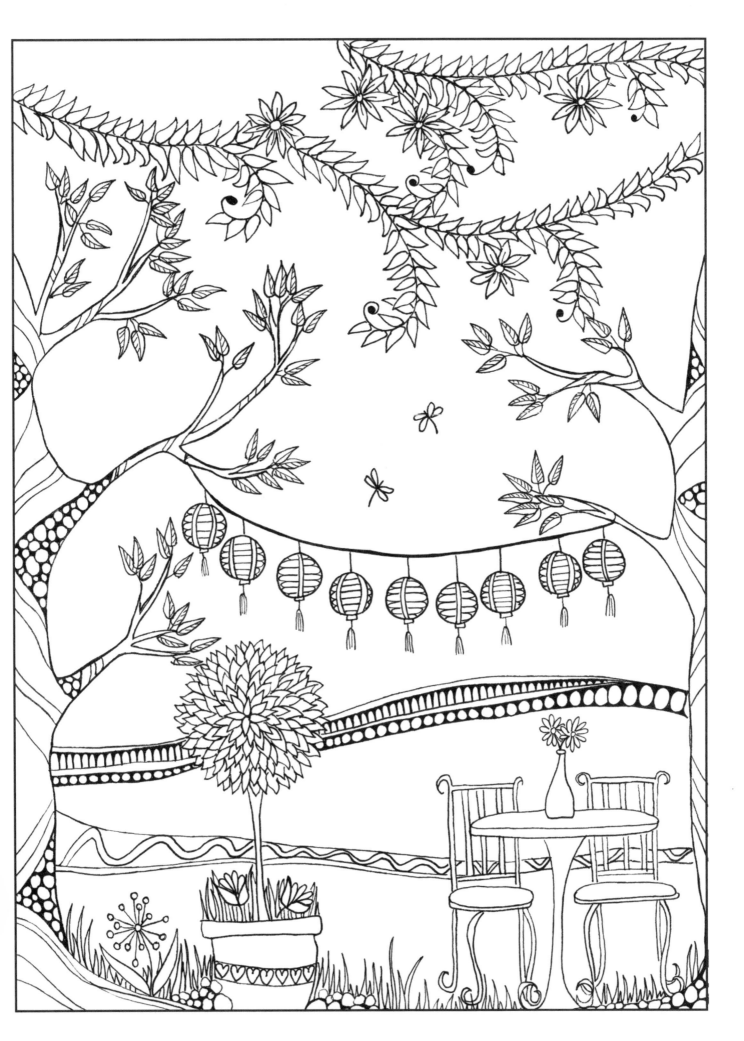

The best thing to hold

onto in life is each other.

—AUDREY HEPBURN

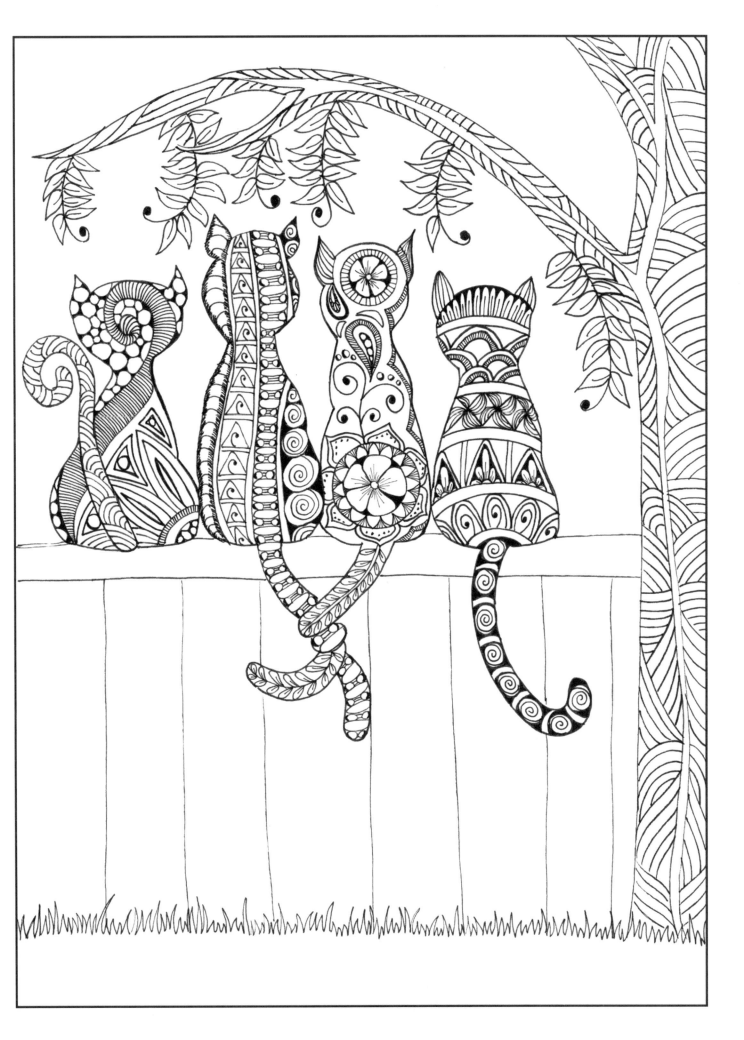

Plant so that your own

heart will grow.

—HAFIZ

Every day brings the chance to bloom again, fearless and brazenly beautiful. Let your heart blossom today.

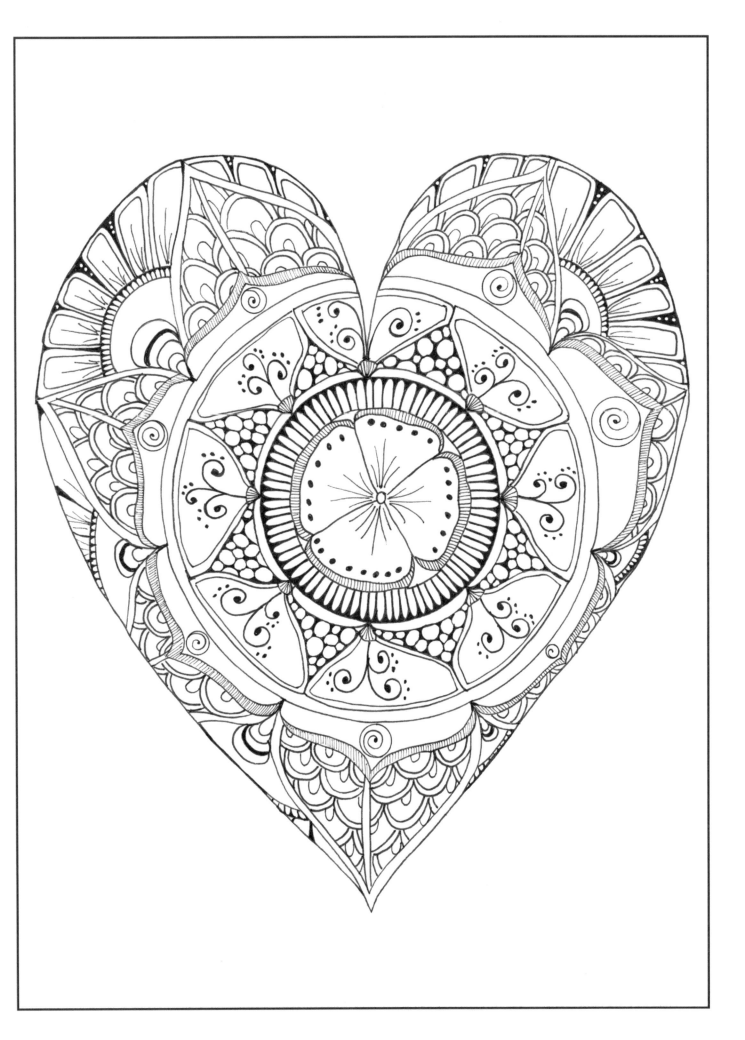

Life is not about waiting for the storm to pass;

it's about learning to dance in the rain.

—VIVIAN GREENE

When puddles dampen your path, jump over them, step around them, or splash through them. Just keep moving! Your journey is made of many steps and sometimes your boots will get wet.

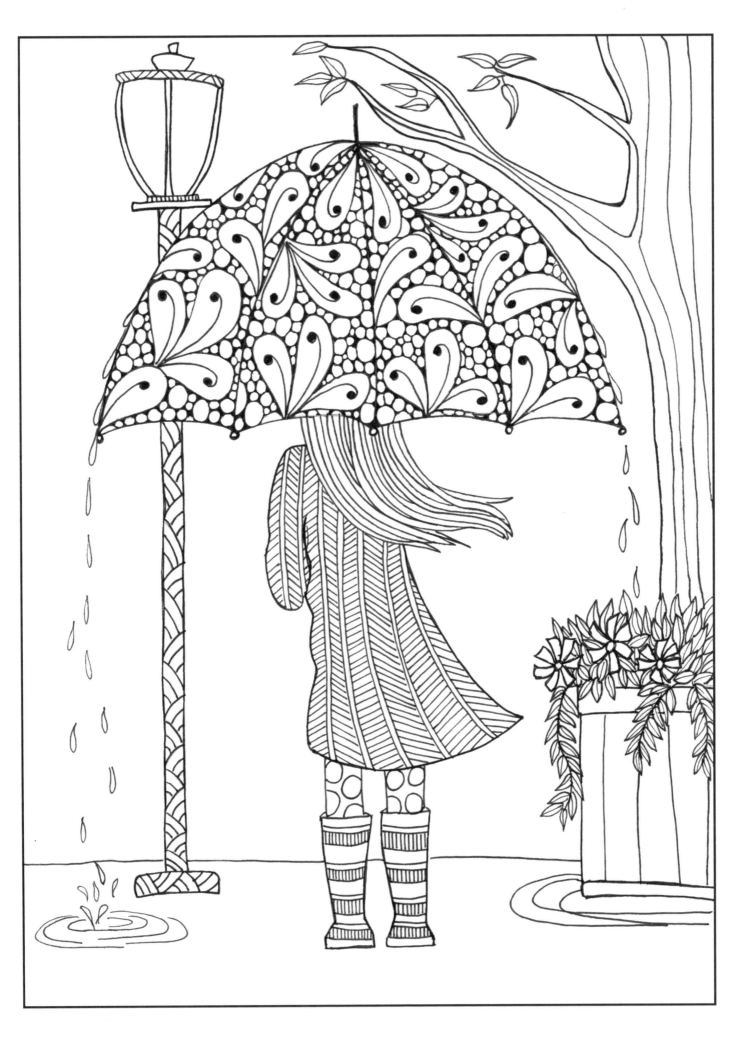

Our deepest fear is not that we are inadequate.

Our deepest fear is that we are powerful beyond measure.

It is our light, not our darkness that most frightens us.

We ask ourselves, Who am I to be brilliant, gorgeous, talented,

fabulous? Actually, who are you not to be?

—MARIANNE WILLIAMSON

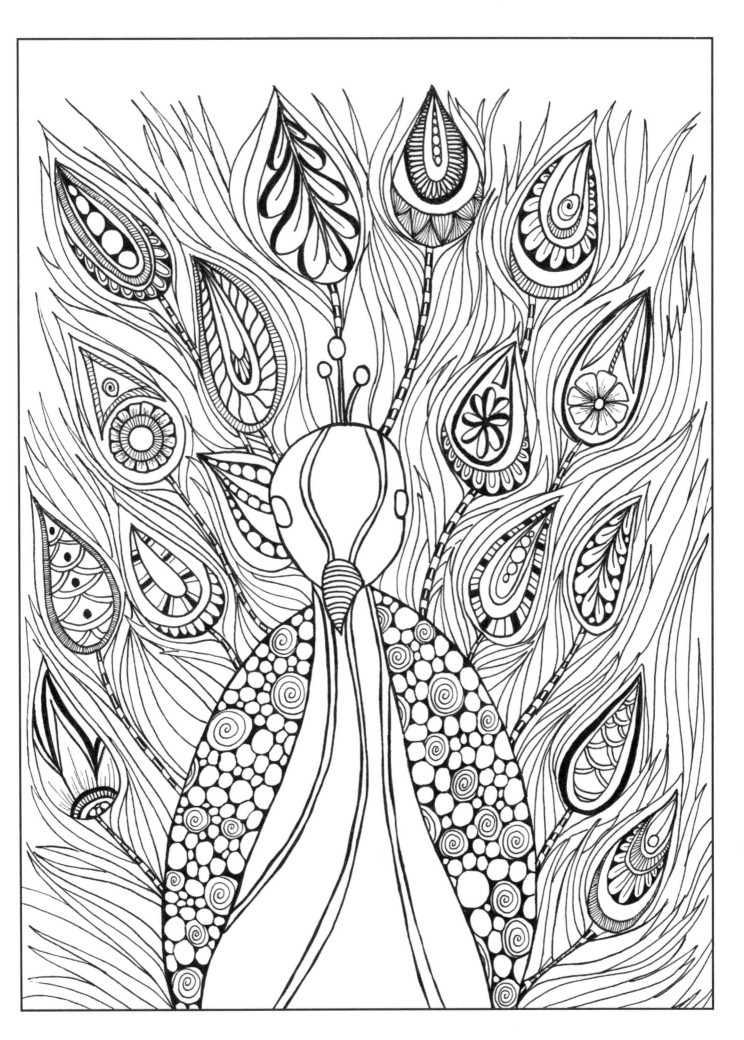

I must be a mermaid. . . .

I have no fear of depths and

a great fear of shallow living.

—ANAÏS NIN

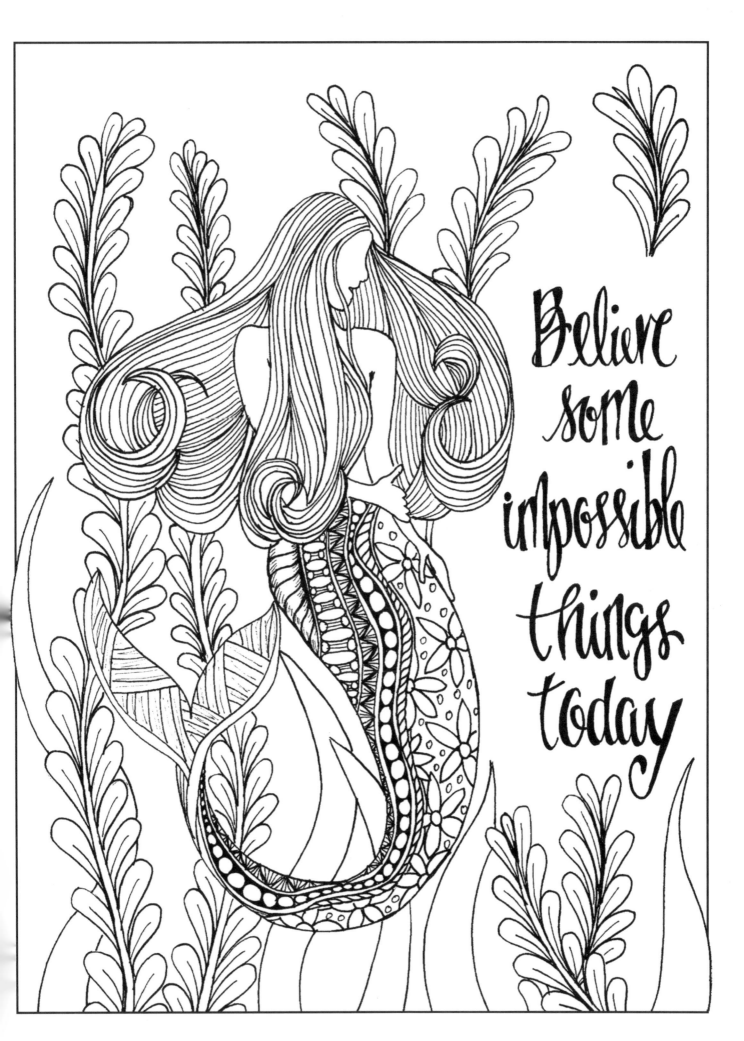

Believe some impossible things today

Plant your own garden and

decorate your own soul, instead of waiting

for someone to bring you flowers.

—VERONICA A. SHOFFSTALL

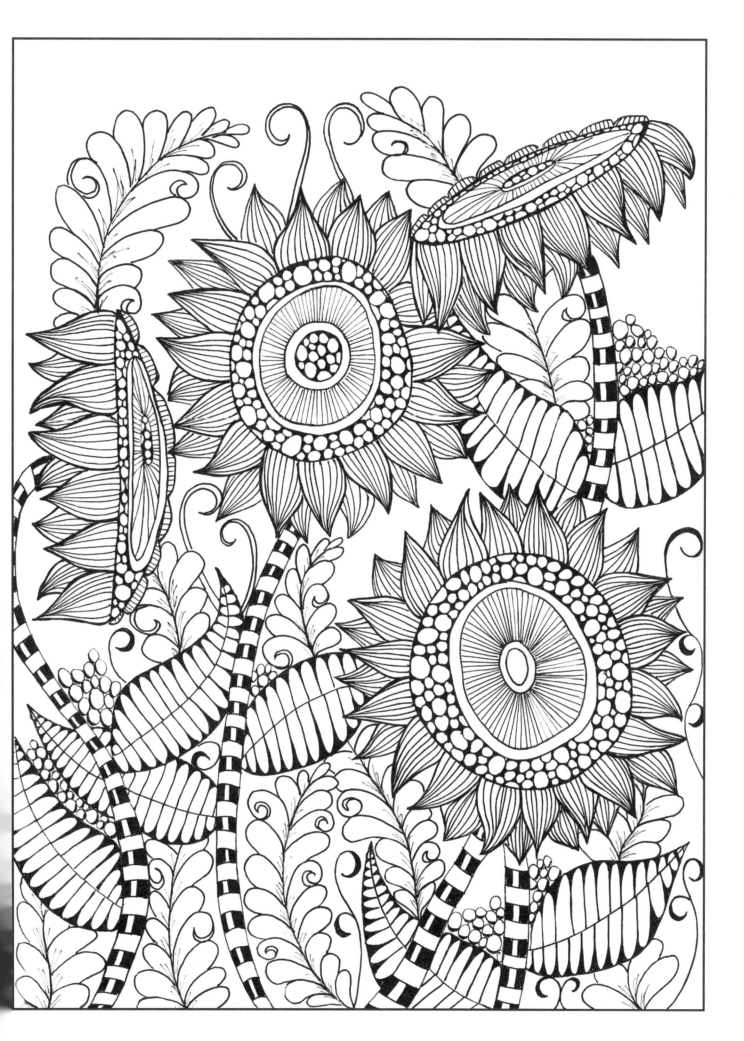

Life is either a daring adventure

or nothing at all.

—HELEN KELLER

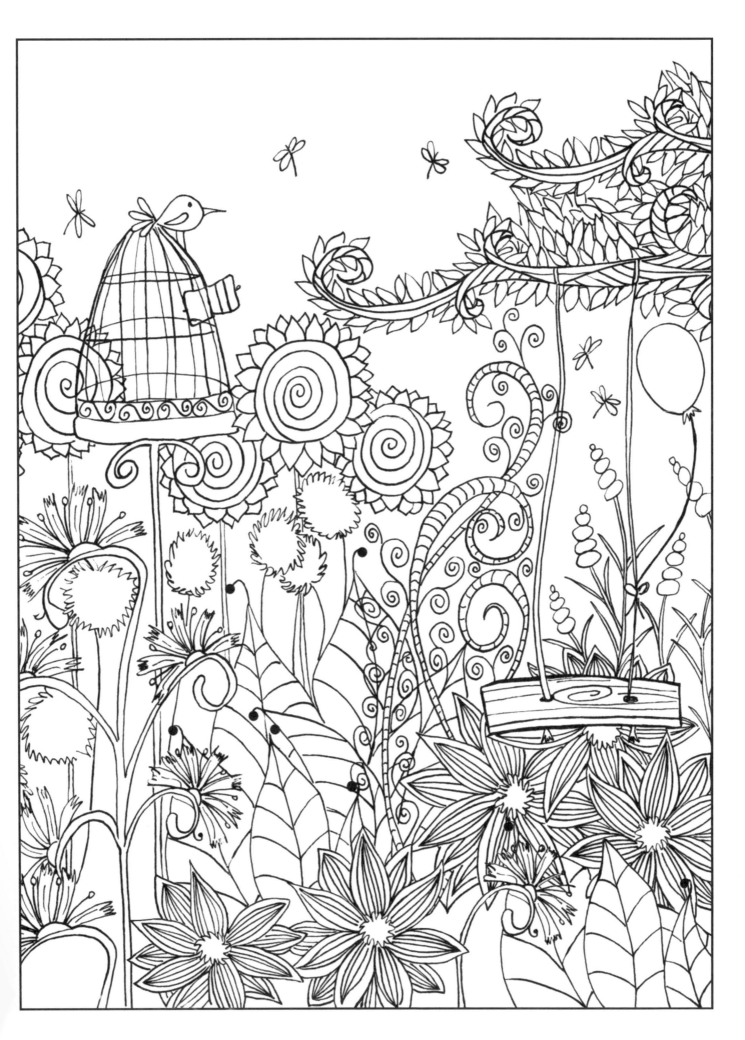

Friends are the family we

choose for ourselves.

—EDNA BUCHANAN

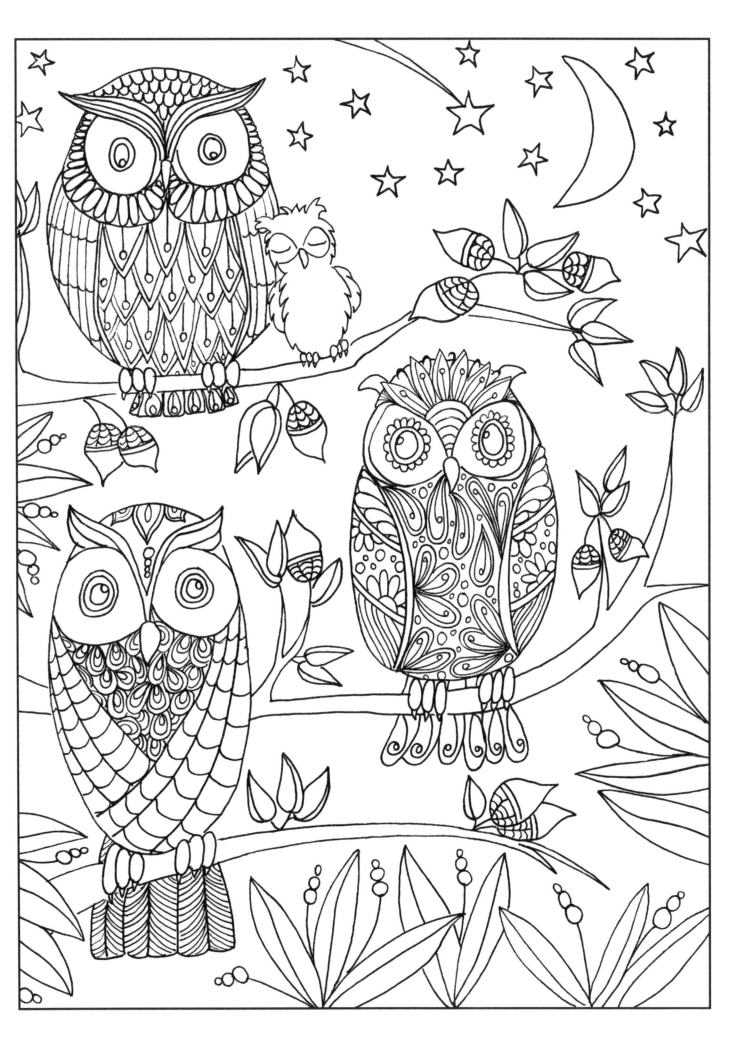

Love yourself first and

everything else falls into line.

—LUCILLE BALL

Self-love is the basis of all love. You are magnificent. Embrace and celebrate that.

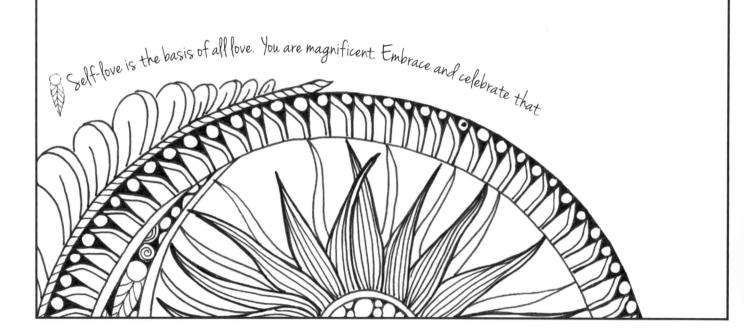

I'm a woman
Phenomenally.

~ Maya Angelou

The flower doesn't dream of the bee.

It blossoms and the bee comes.

—MARK NEPO

Surround yourself only with people

who are going to lift you higher.

—OPRAH WINFREY

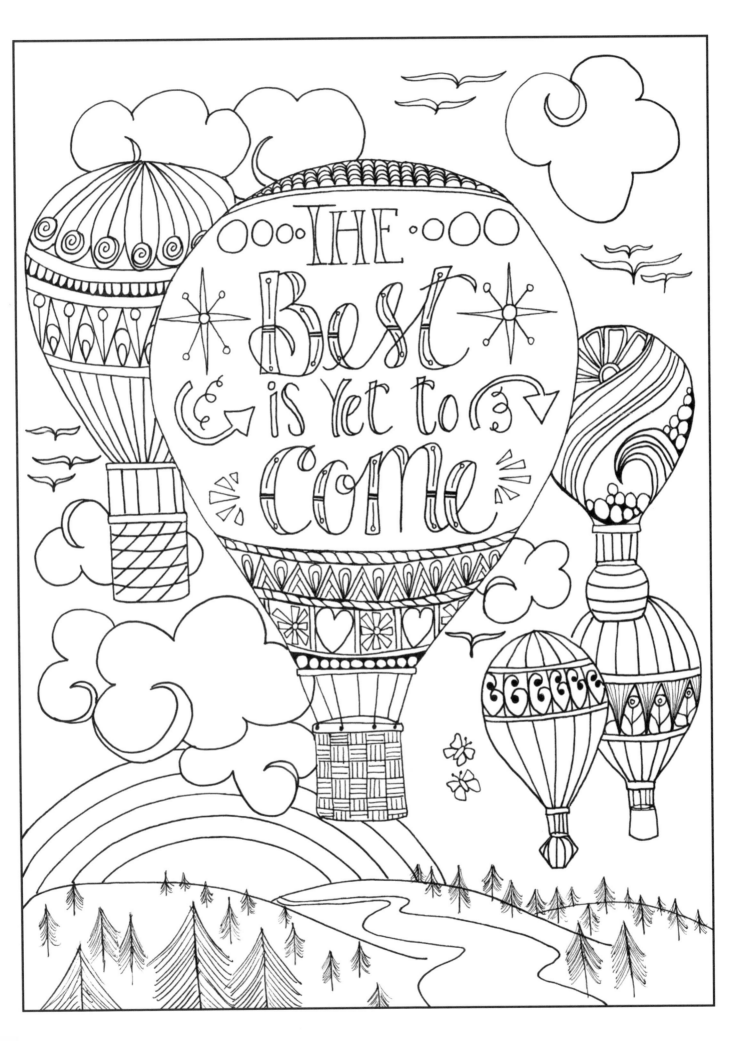

Don't be afraid to go out on a limb.

That's where the fruit is.

—H. JACKSON BROWNE

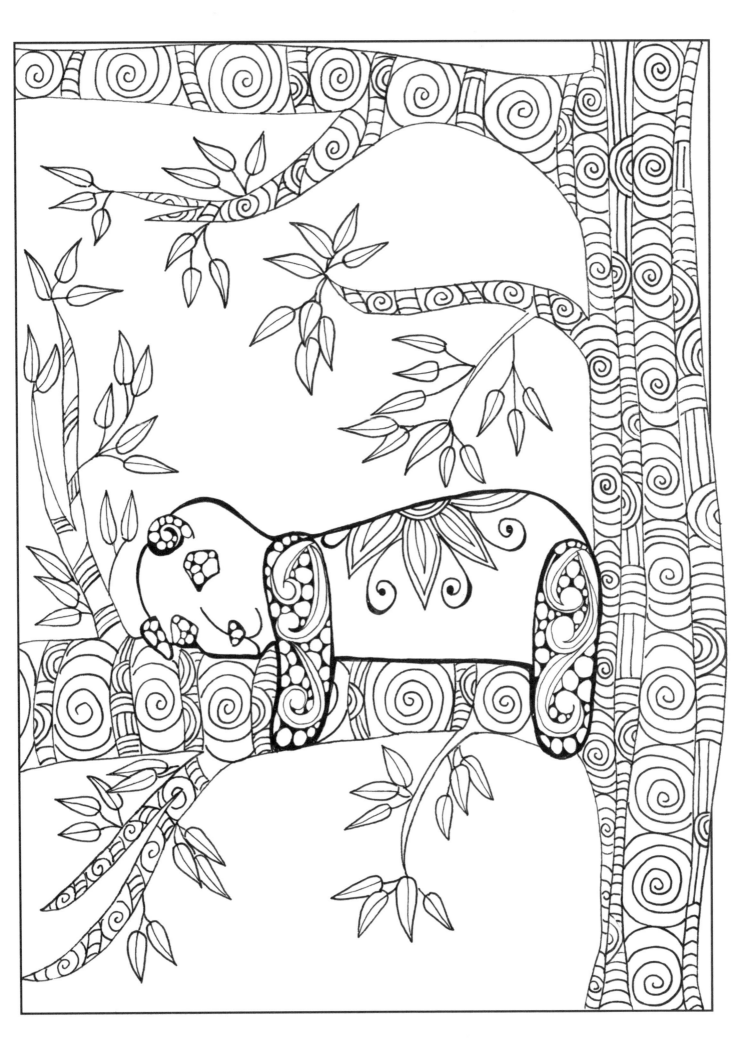

A woman is like a tea bag;

you never know how strong she is

until she gets into hot water.

—ELEANOR ROOSEVELT

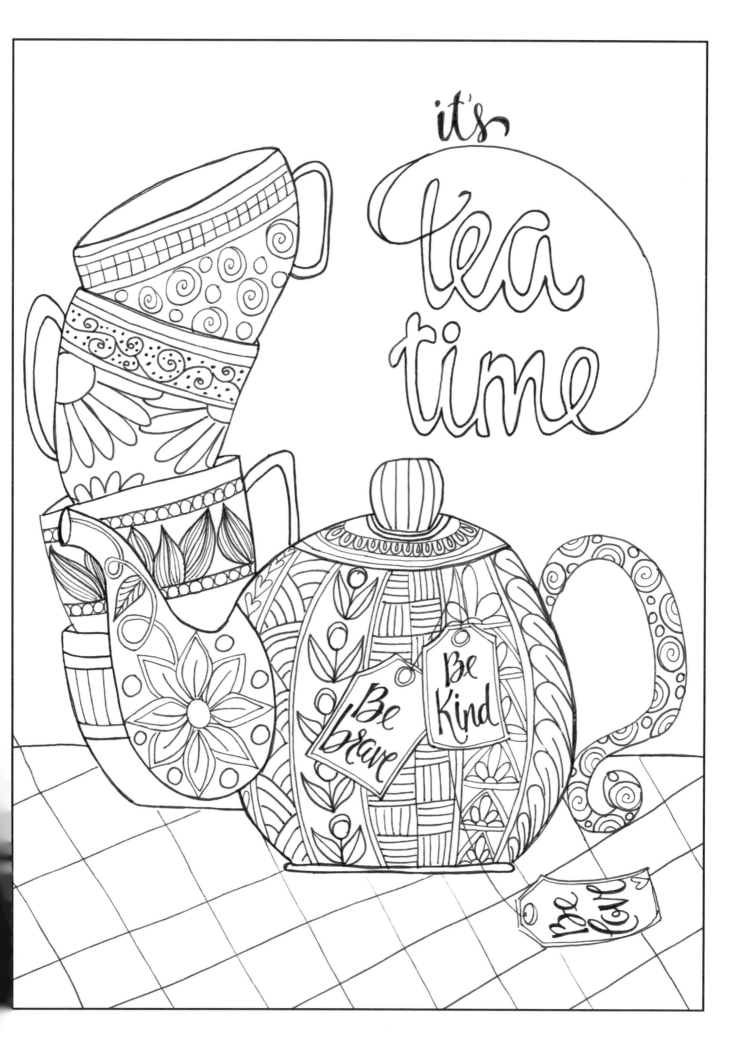

In the midst of winter,

I finally learned that there was

within me an invincible summer.

—ALBERT CAMUS

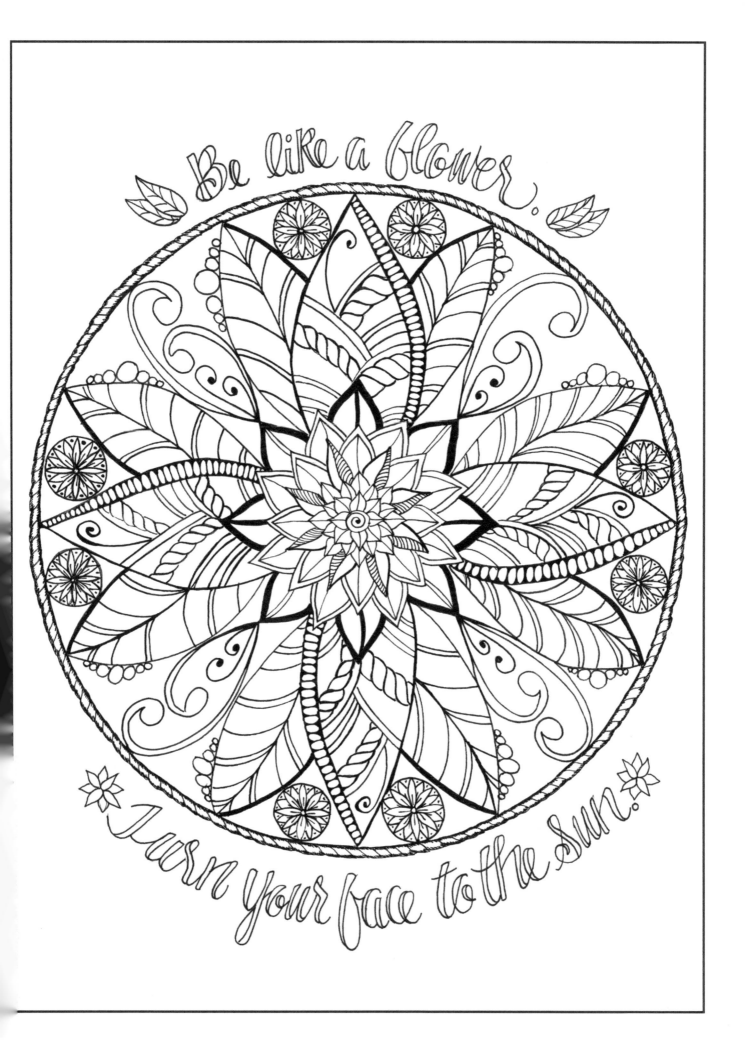

I want to sing like the birds sing,

not worrying about who hears or what they think.

—RUMI

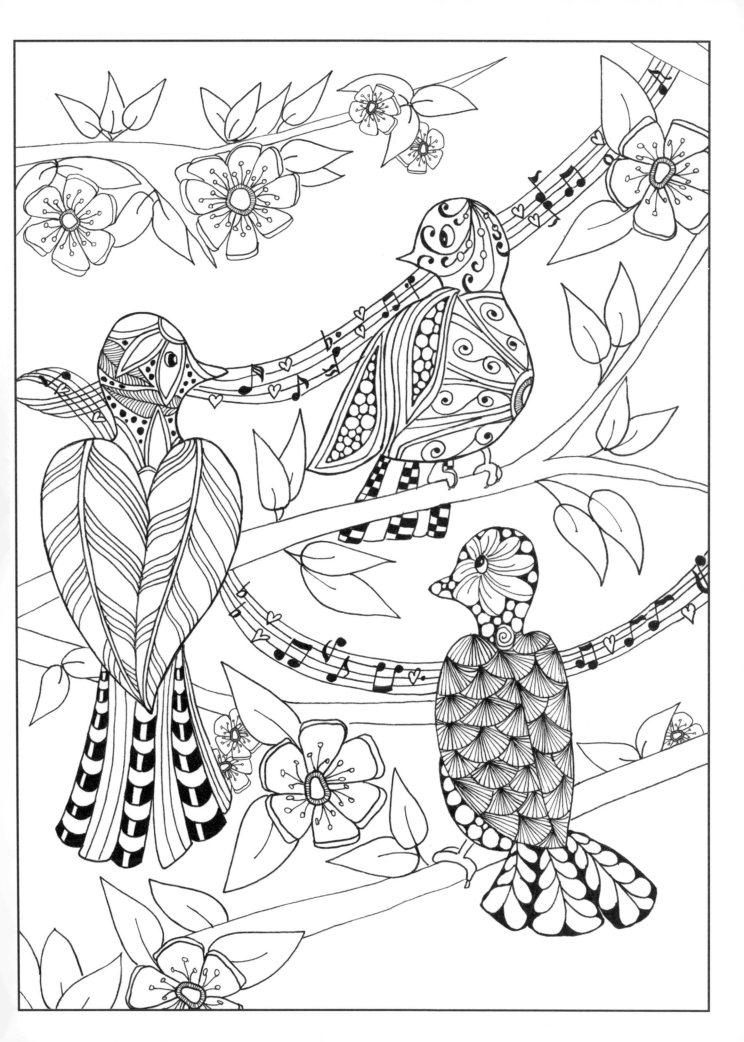

Inside everyone is a great shout

of joy waiting to be born.

—DAVID WHYTE

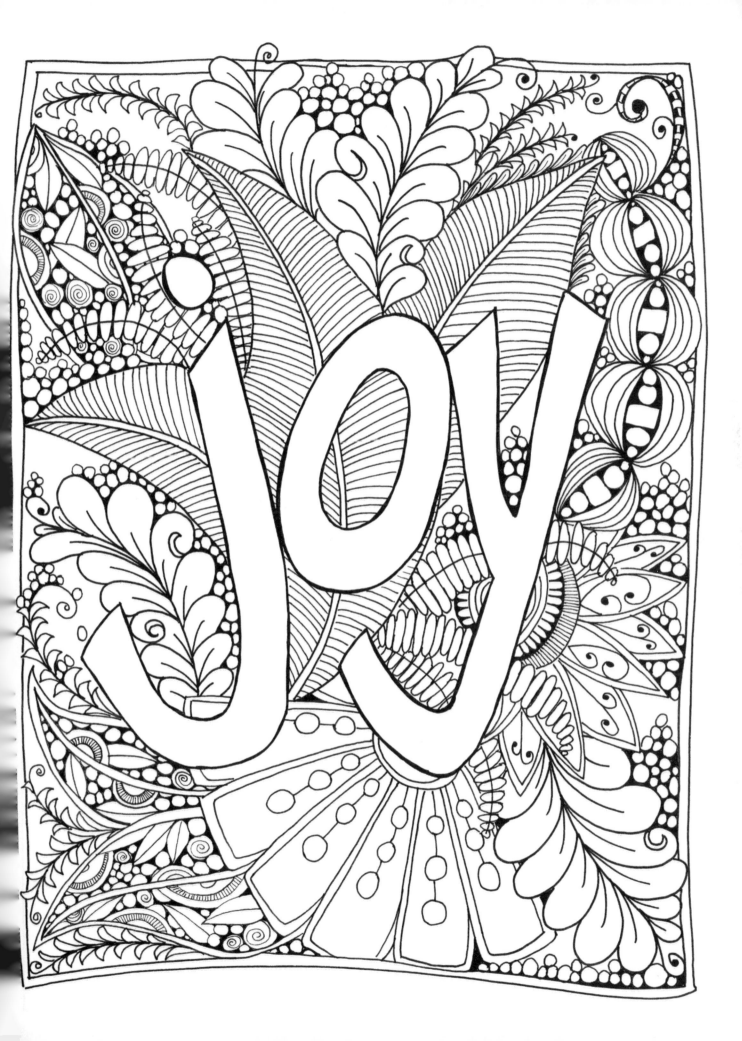

If you want others to be happy, practice compassion.

If you want to be happy, practice compassion.

— HIS HOLINESS, THE DALAI LAMA

Love doesn't happen to us; it happens because of us. Dare to share love and it will come back to you. Choose love.

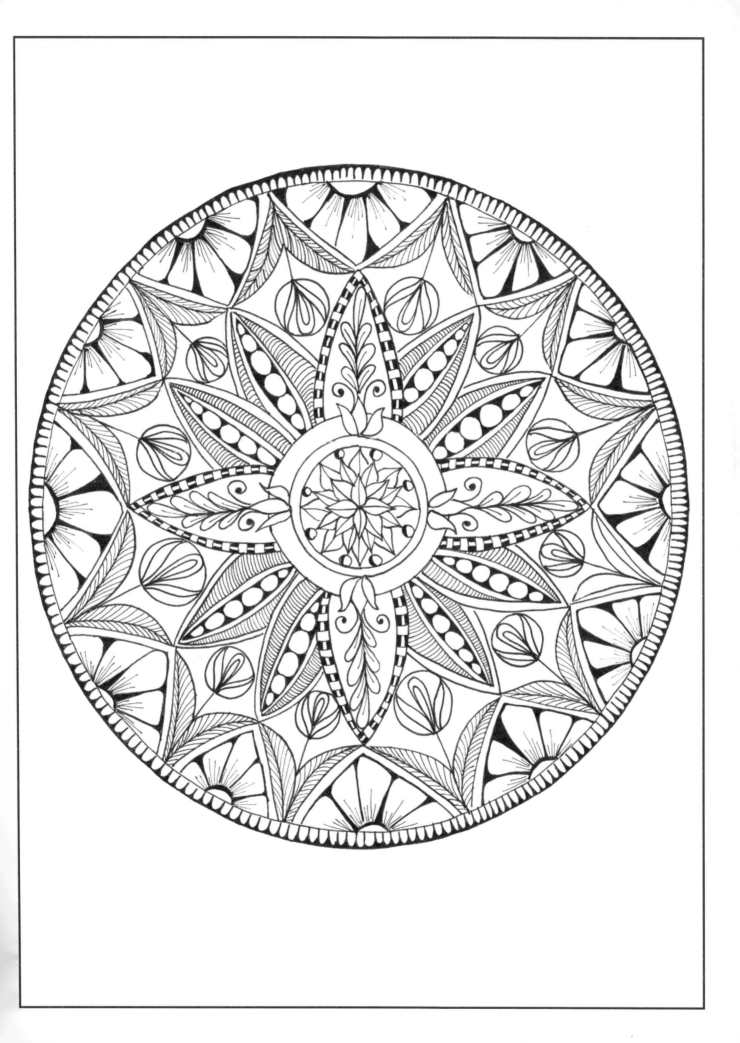

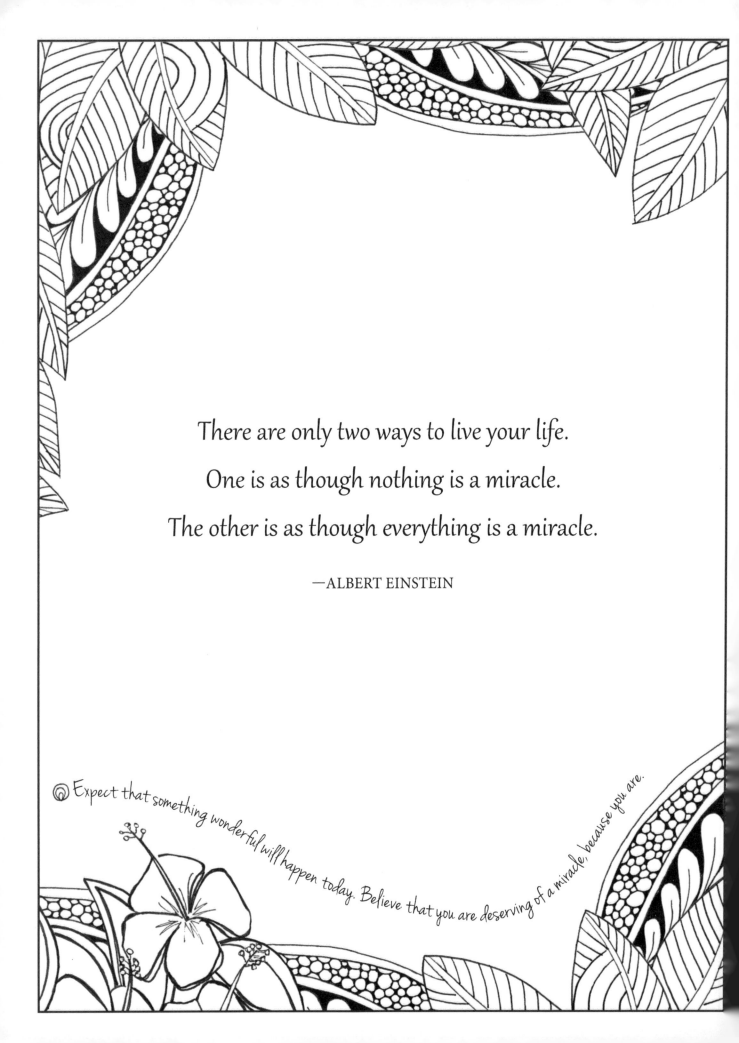

There are only two ways to live your life.

One is as though nothing is a miracle.

The other is as though everything is a miracle.

—ALBERT EINSTEIN

Expect that something wonderful will happen today. Believe that you are deserving of a miracle, because you are.

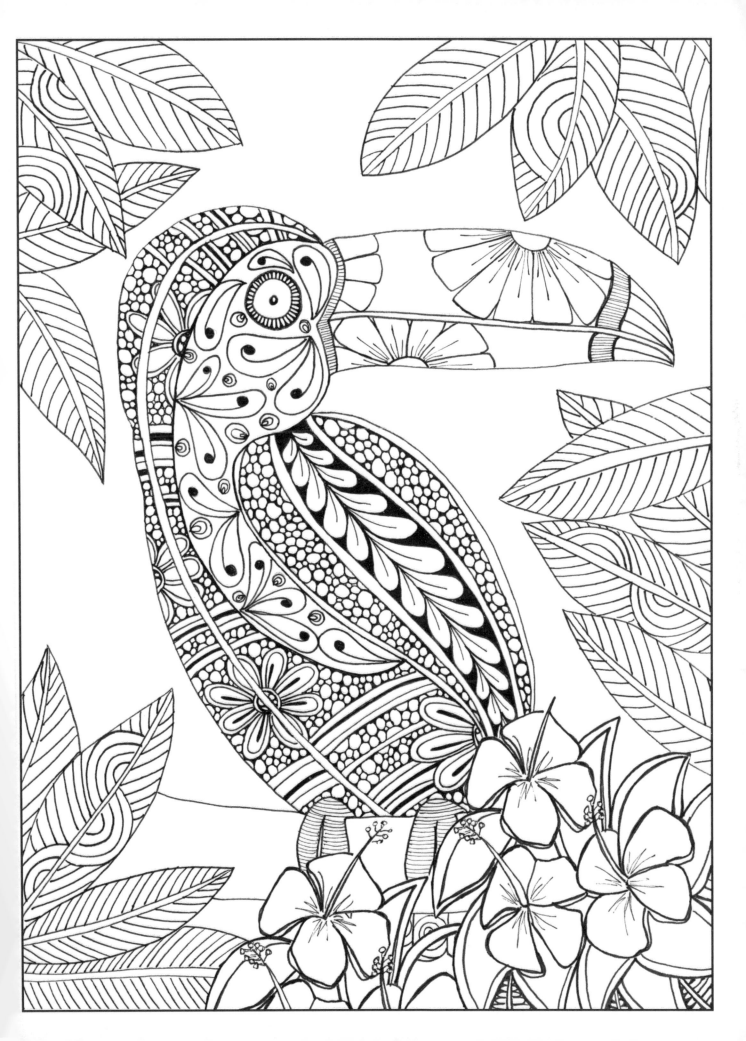

Promise me you'll always remember:

You're braver than you believe,

and stronger than you seem,

and smarter than you think.

—A.A. MILNE

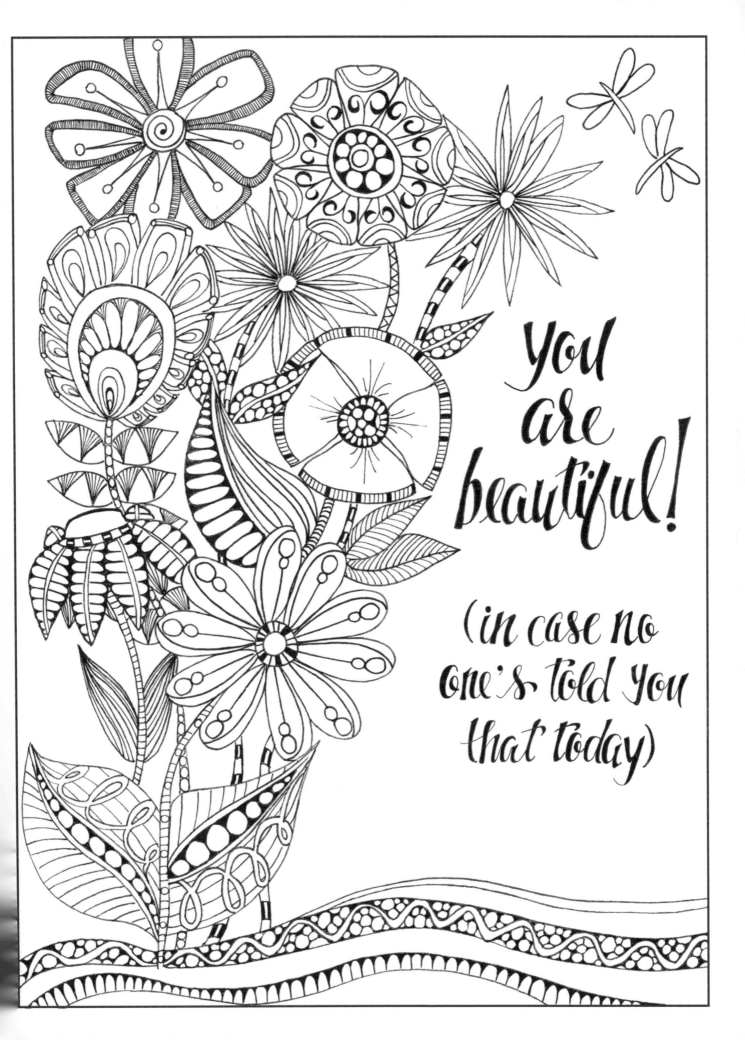

you are beautiful!

(in case no one's told you that today)

If the only prayer you said in your whole life was,

"thank you," that would suffice.

—MEISTER ECKHART

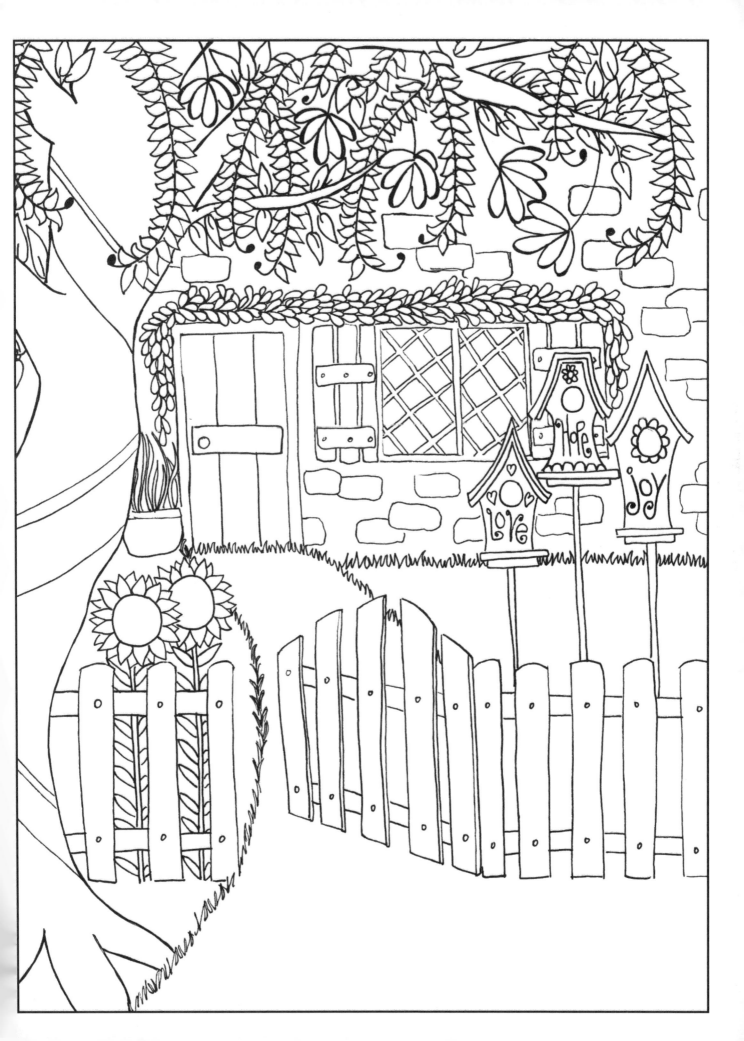

Some days there won't be a song in your heart.

Sing anyway.

—EMORY AUSTIN

Find what makes your heart sing. Do more of that.

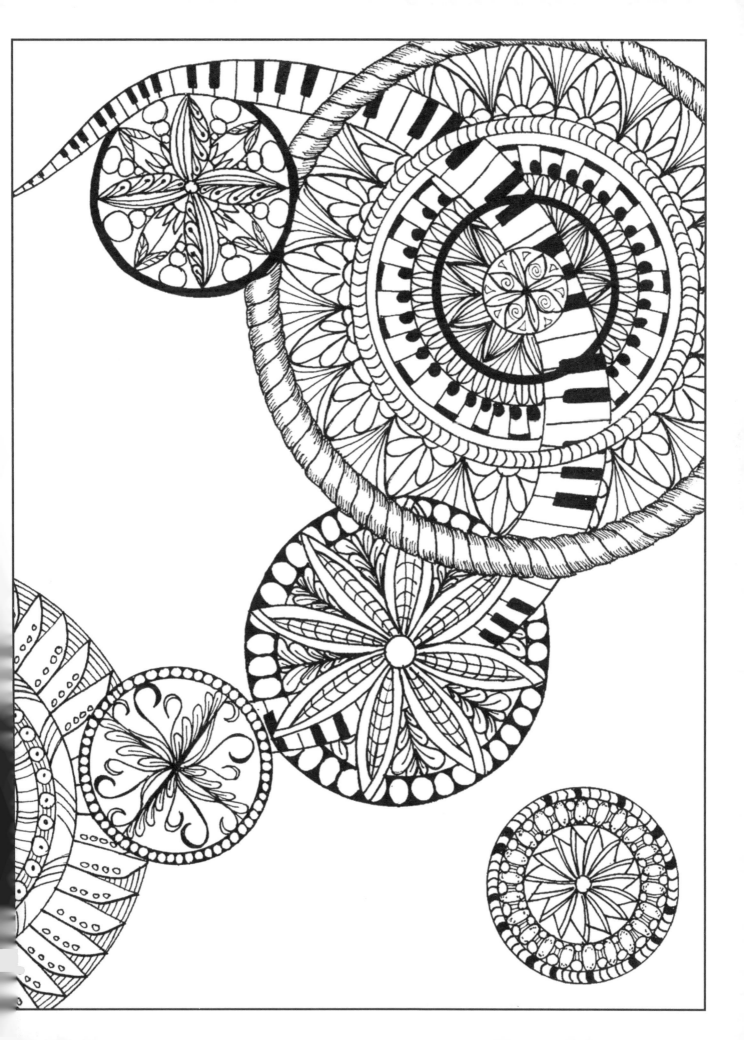

And still, after all this time,

the Sun has never said to the Earth,

"You owe me."

Look what happens with love like that.

It lights up the sky.

—RUMI

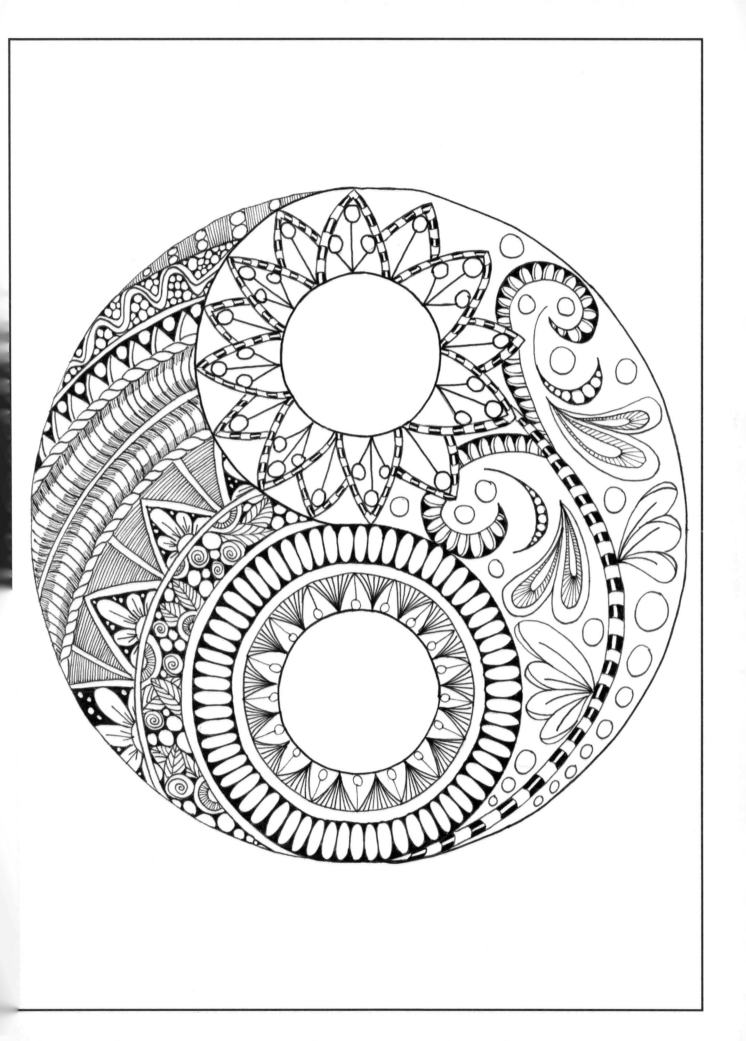

Above all, be the heroine of your life,

not the victim.

—NORA EPHRON

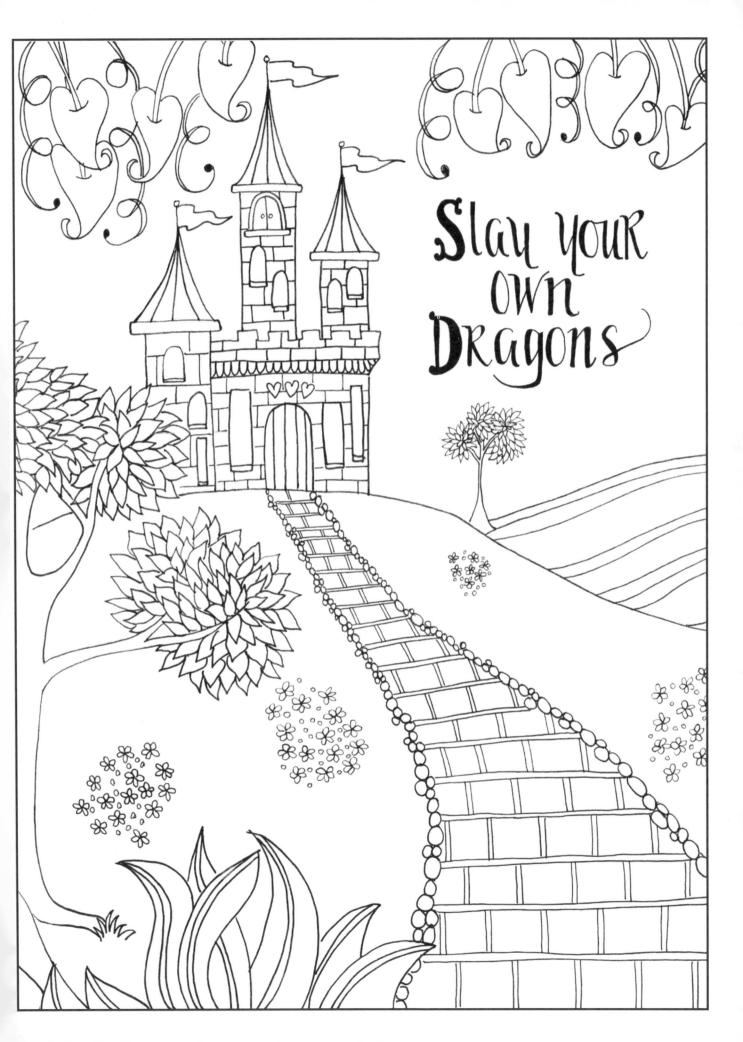

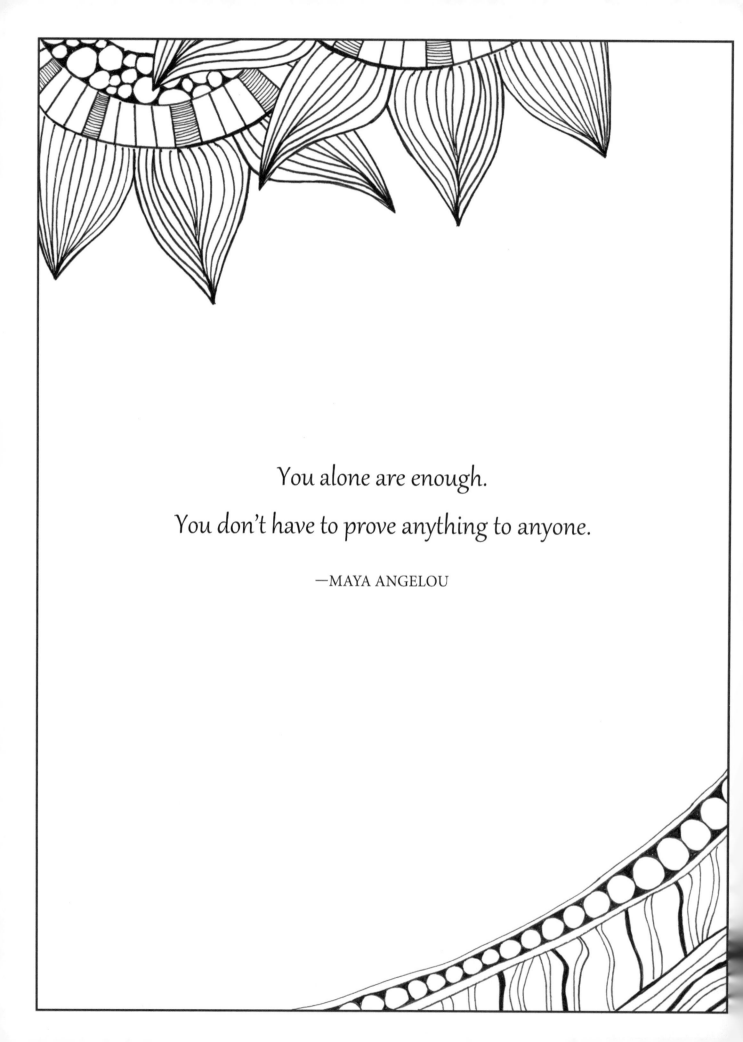

You alone are enough.

You don't have to prove anything to anyone.

—MAYA ANGELOU

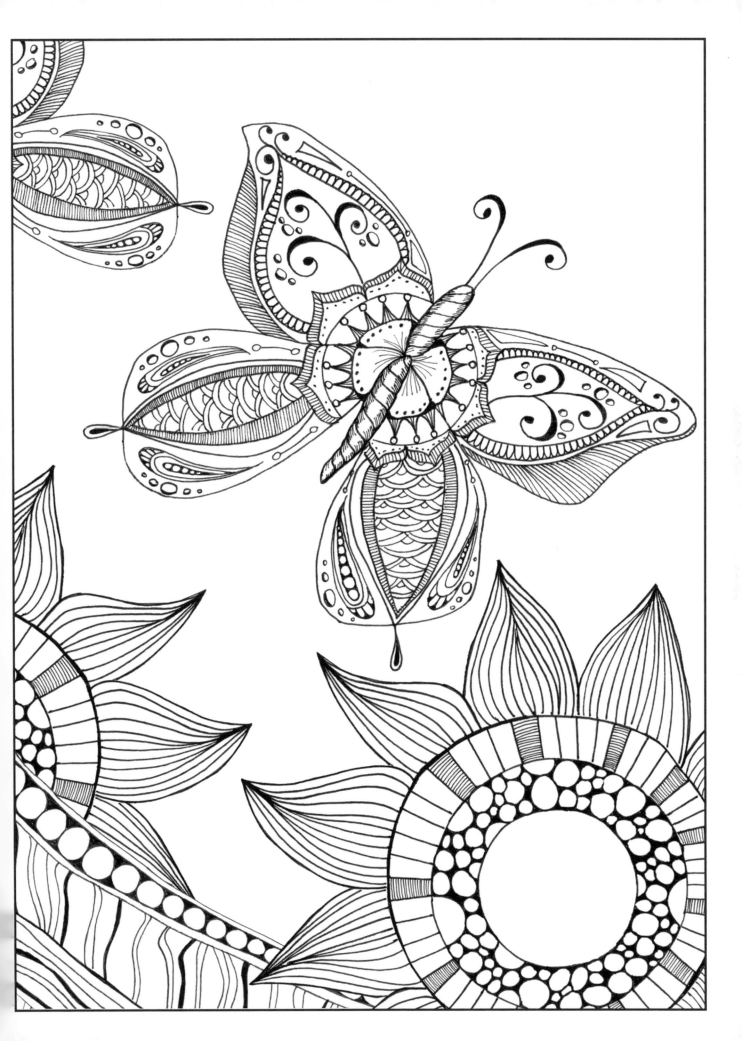

Always say "yes" to the present moment . . .
Surrender to what is. Say "yes" to life—and
see how life suddenly starts working for
you rather than against you.

—ECKHART TOLLE

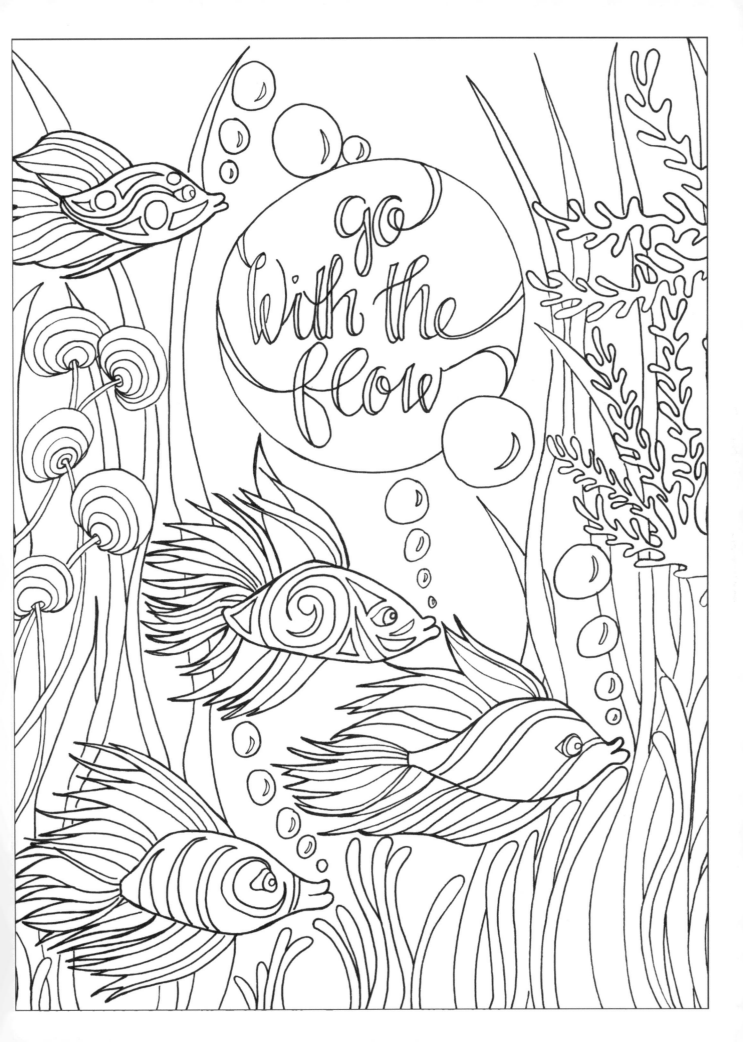

Nothing is impossible;

the word itself says, "I'm possible."

—AUDREY HEPBURN

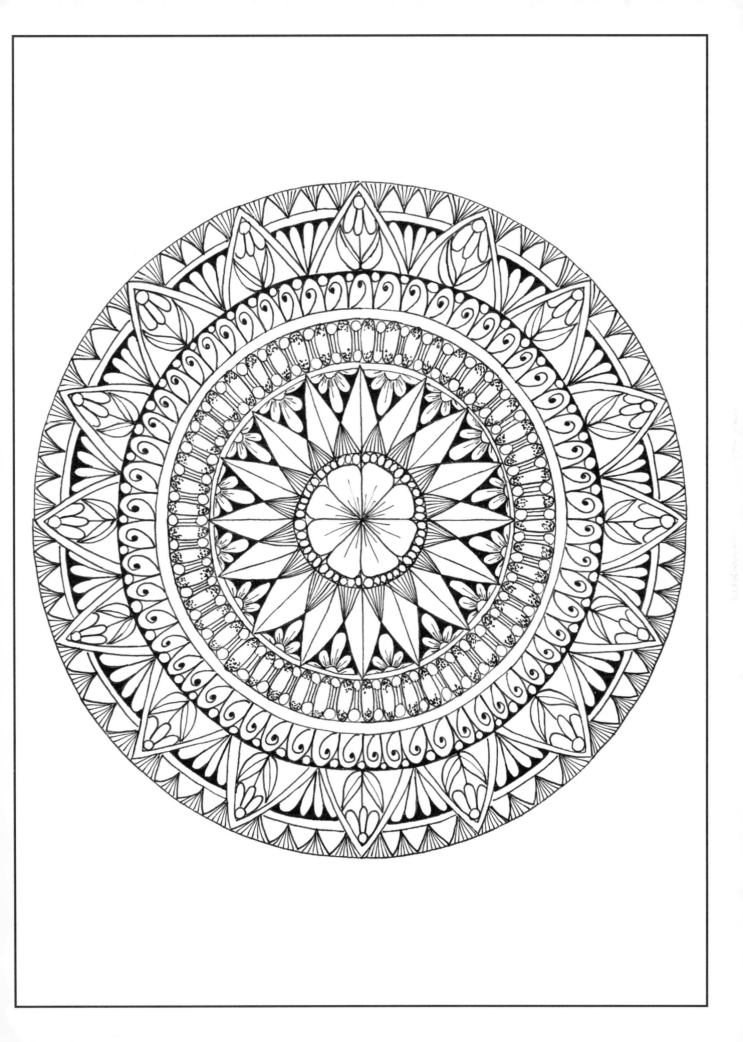

And the day came when the risk to

remain tight in a bud was more painful

than the risk it took to blossom.

—ANAÏS NIN

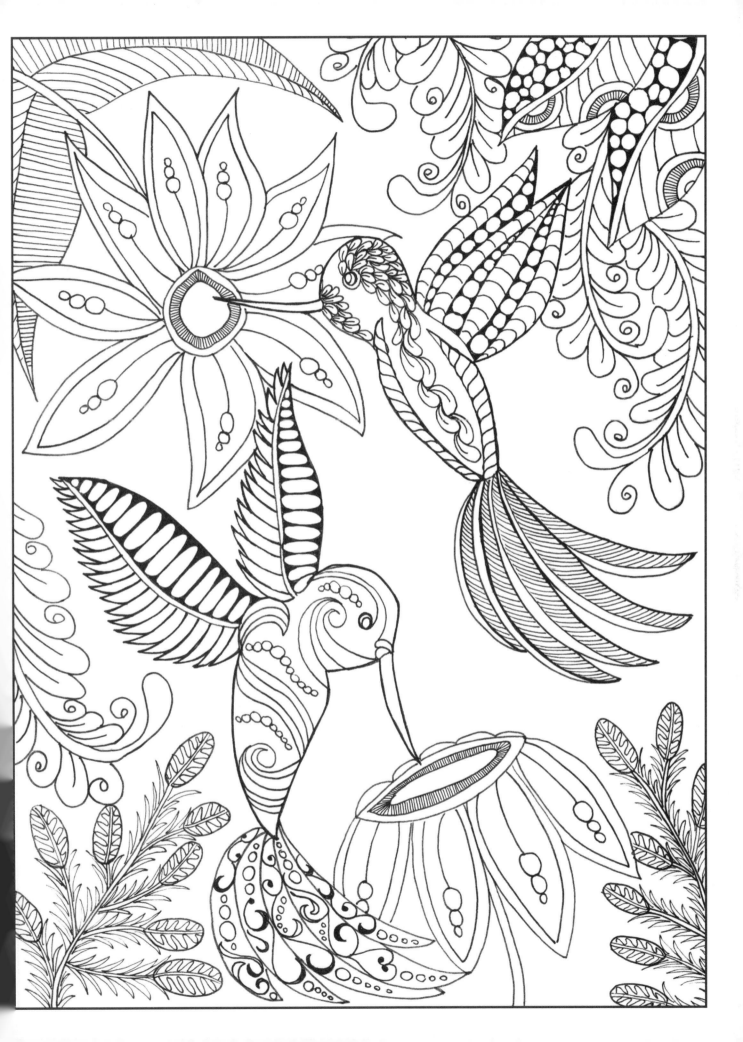

Don't ask what the world needs.

Ask what makes you come alive, and go do it.

Because what the world needs is people who have come alive.

—HOWARD THURMAN

Say "yes" to new adventures!

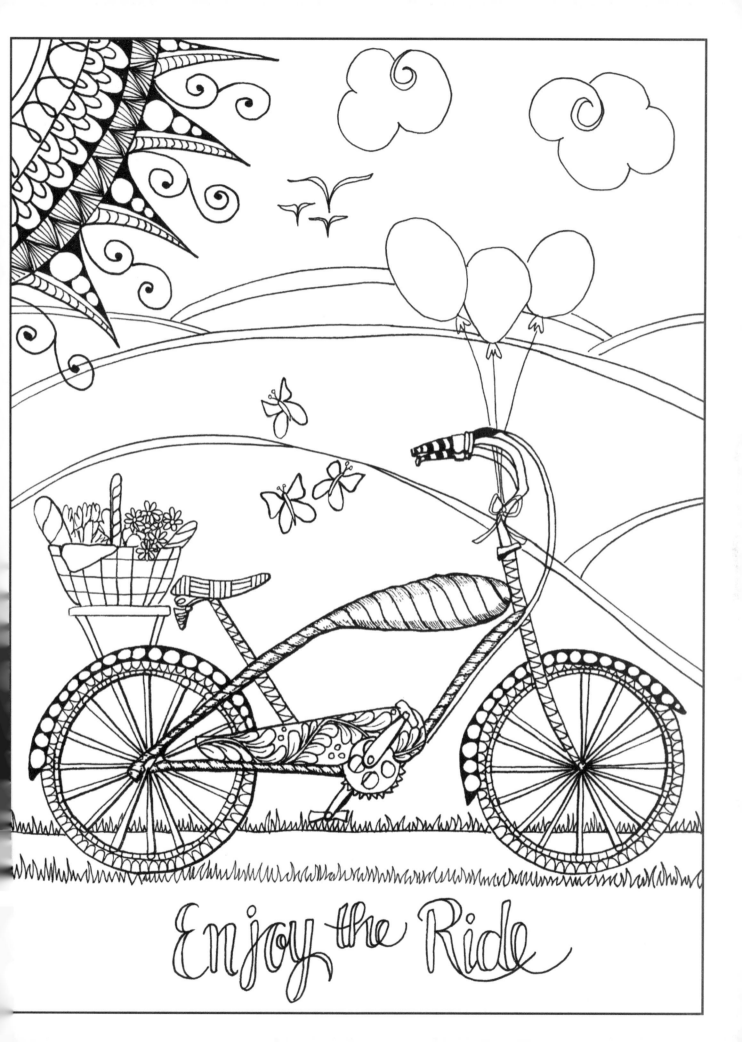

Miracles come in moments.

Be ready and willing.

—WAYNE DYER

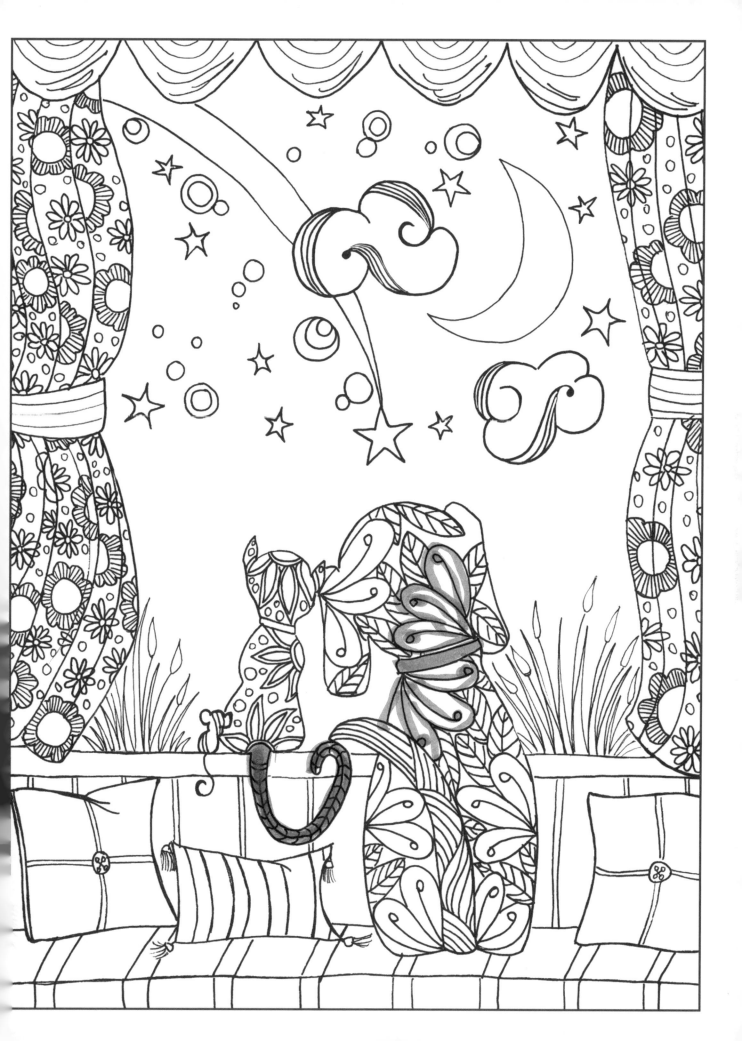

You've always had the power my dear,

you just had to learn it for yourself.

—GLINDA, *THE WIZARD OF OZ*

Have faith in your heart's wisdom to guide you.

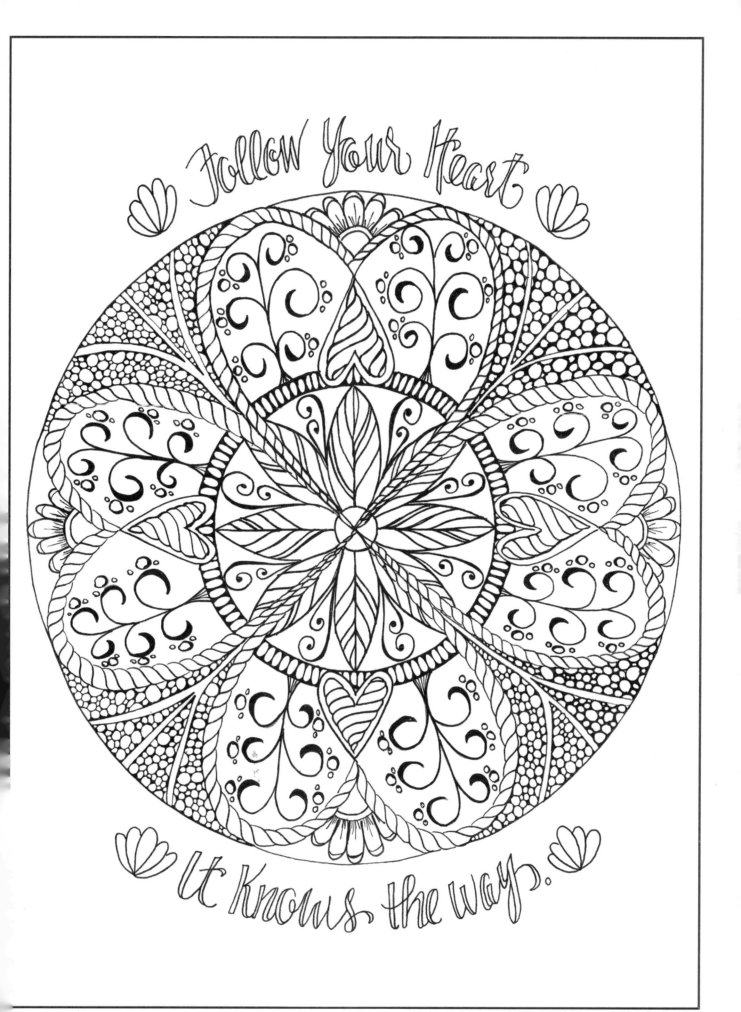

How to Make Your Own Mandala

Now that you are hopefully inspired to create even more masterpieces, try your hand at a mandala.

Mandalas are much easier to draw than you think!

STEP 1

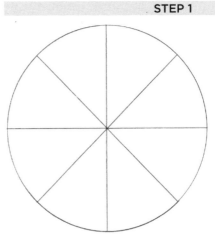

Draw your center point and your outer circle (in pencil, so you can erase later).

STEP 2

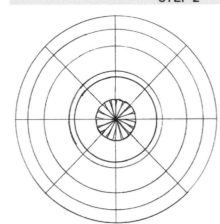

Draw additional circles in random sizes. Start filling things in! I tend to start in the middle, but you can start anywhere.

STEP 3

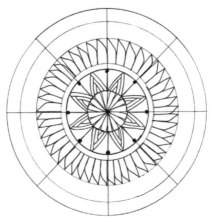

Use your grid lines to help you space your patterns. Don't worry about getting everything perfect, just follow your pattern.

STEP 4

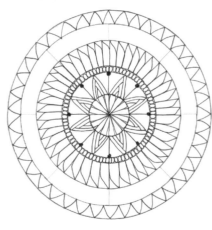

You can see that my patterns are not perfectly spaced/shaped. It won't matter in the end, I promise. Mandalas are, in part, an exercise in trust.

STEP 5

As you go back and add details, imperfections become less obvious.

STEP 6

Fill in some of your blank spaces with words that are personally meaningful.
—JCW